THE SONG OF THE
THREE HOLY CHILDREN

ILLUSTRATED BY PAULINE BAYNES

Henry Holt and Company
New York

The text of this edition is taken from
The Book of Common Prayer, 1662.

Illustrations copyright © 1986 by Pauline Baynes
All rights reserved, including the right to reproduce
this book or portions thereof in any form.
Published by Henry Holt and Company, Inc.
521 Fifth Avenue, New York, New York 10175.
Originally published in Great Britain
by Methuen Children's Books Ltd.

Library of Congress Cataloging in Publication Data:

Benedicite, omnia opera Domini. English.
The Song of the Three Holy Children.

Summary: Apocryphal insertions to the Book of
Daniel, in which Shadrach, Meshach, and Abednego, who
have been cast into a fiery furnace by Nebuchadnezzar,
call upon the angels, all things in nature, and people
to praise the Lord.
1. Praise of God—Biblical teaching. 2. Nature—
Biblical teaching. [1. Bible. O.T. Apochrypha.
2. Praise of God] I. Baynes, Pauline, ill. II. Title.
III. Title: Three Holy Children. IV. Title: Song of
the 3 Holy Children. V. Title: 3 Holy Children.
BS1783 1986 229'.5 86-11952
ISBN: 0-8050-0134-4
First American Edition
Printed in Hong Kong by South China Printing Co.
1 3 5 7 9 10 8 6 4 2

ISBN 0-8050-0134-4

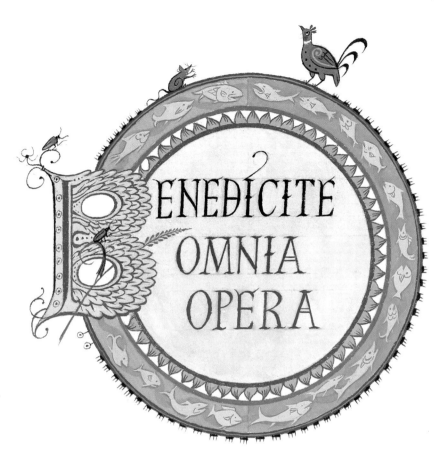

BENEDICITE OMNIA OPERA

O all ye works of the Lord,
bless ye the Lord:
praise him and magnify
him for ever.

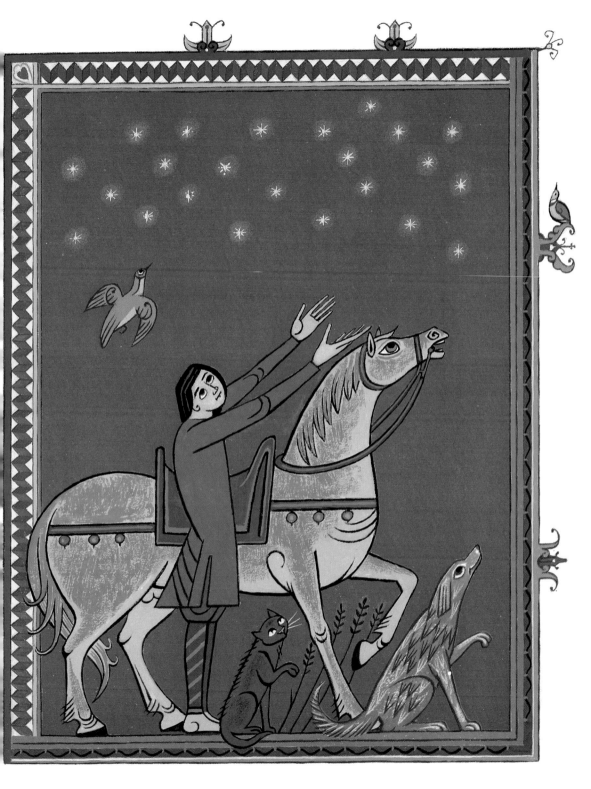

O ye Angels of the Lord,
bless ye the Lord:
praise him, and magnify
him for ever.

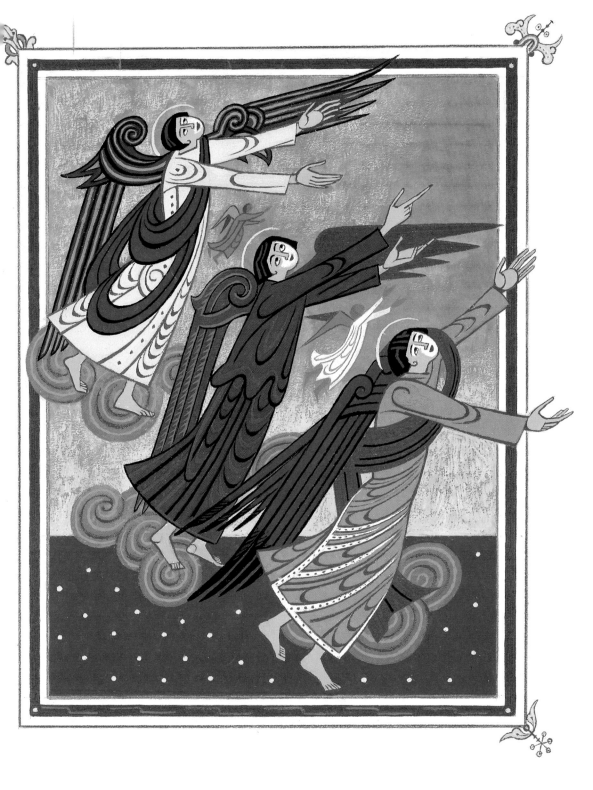

O ye Heavens,
 bless ye the Lord:
 praise him, and magnify
 him for ever.
 O ye Waters that be
 above the Firmament,
 bless ye the Lord:
 praise him, and magnify
 him for ever.

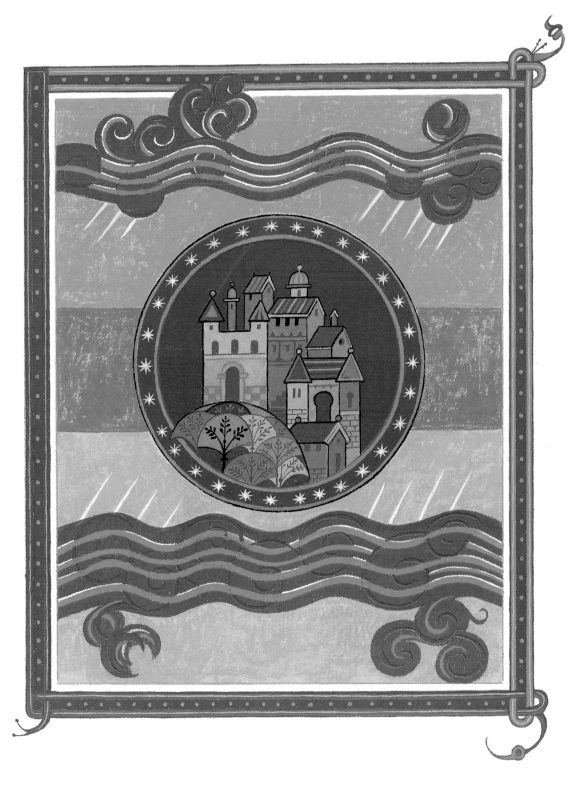

O all ye Powers of the Lord,

bless ye the Lord:

praise him, and magnify

him for ever.

O ye Sun and Moon,

bless ye the Lord:

praise him, and magnify

him for ever.

O ye Stars of Heaven,

bless ye the Lord:

praise him, and magnify

him for ever.

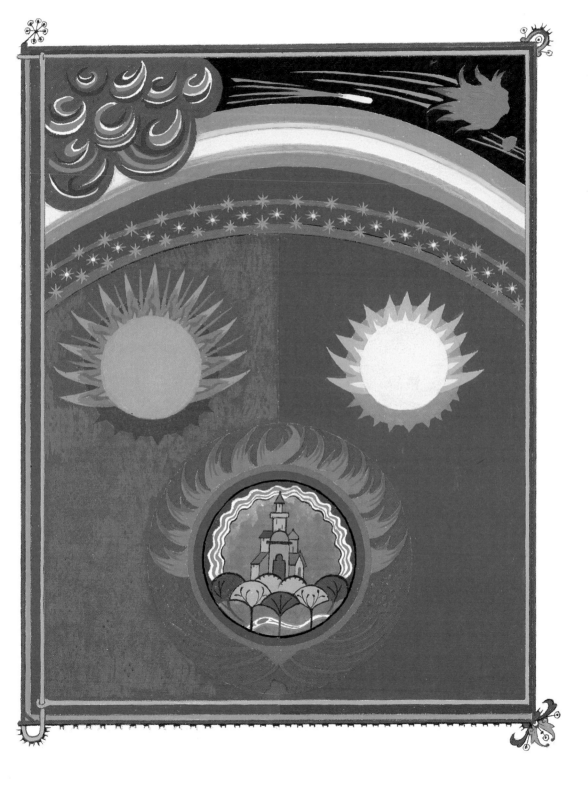

O ye Showers and Dew,

bless ye the Lord:

praise him, and magnify

him for ever.

O ye Winds of God,

bless ye the Lord:

praise him, and magnify

him for ever.

O ye Fire and Heat,

bless ye the Lord:

praise him, and magnify

him for ever.

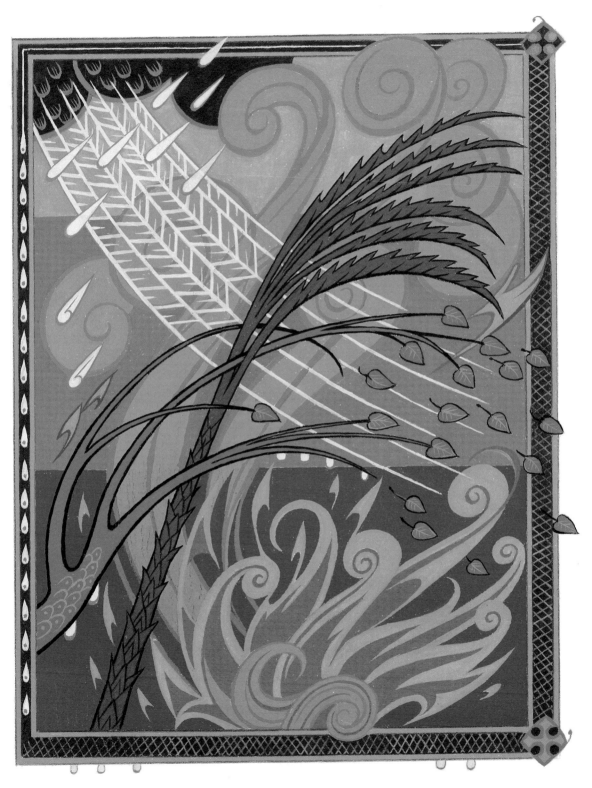

O ye Winter and Summer,
bless ye the Lord:
praise him, and magnify
him for ever.
O ye Dews and Frosts,
bless ye the Lord:
praise him, and magnify
him for ever.
O ye Frost and Cold,
bless ye the Lord:
praise him, and magnify
him for ever.
O ye Ice and Snow,
bless ye the Lord:
praise him, and magnify
him for ever.

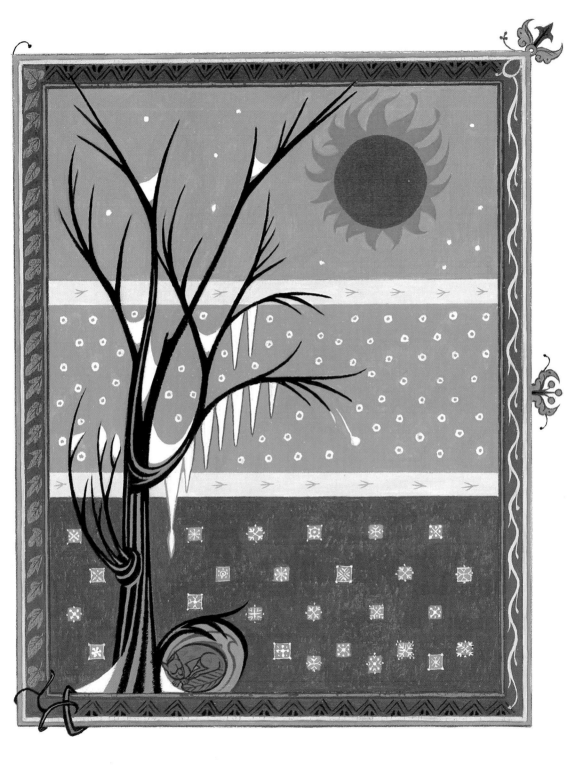

O ye Nights and Days,
 bless ye the Lord:
 praise him, and magnify
 him for ever.
 O ye Light and Darkness,
 bless ye the Lord:
 praise him, and magnify
 him for ever.
 O ye Lightnings and Clouds
 bless ye the Lord:
 praise him, and magnify
 him for ever.

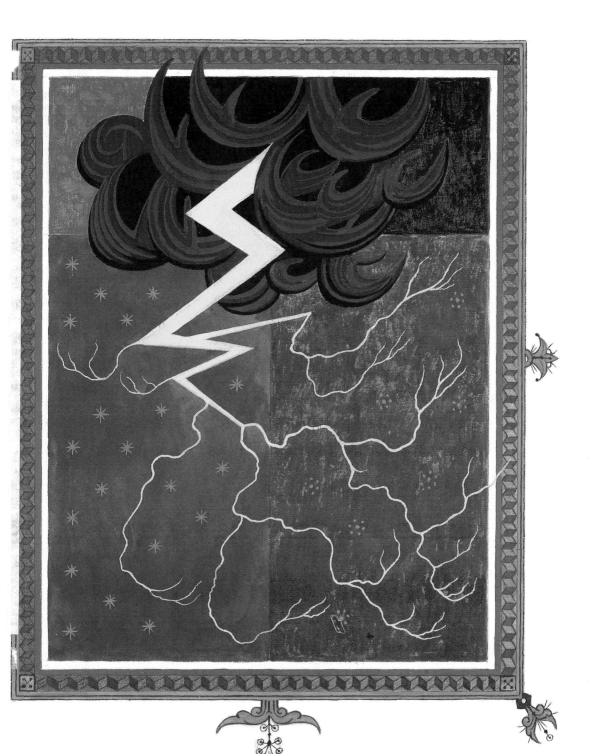

O let the Earth
bless the Lord:
yea, let it
praise him,
and magnify
him for ever.

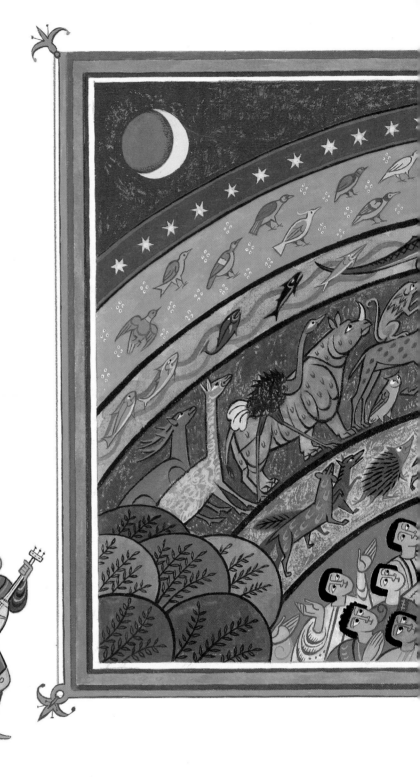

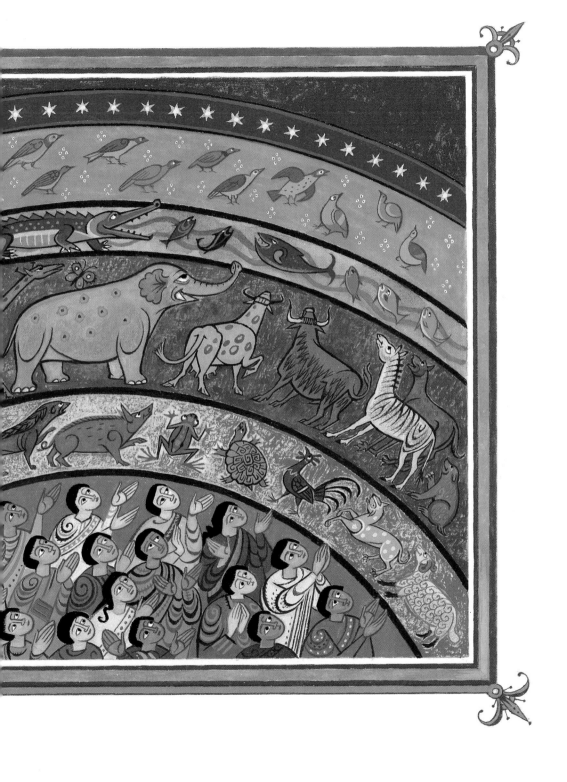

O ye Mountains and Hills,
bless ye the Lord:
praise him, and magnify
him for ever.
O all ye Green Things
upon the Earth,
bless ye the Lord,
praise him, and magnify
him for ever.

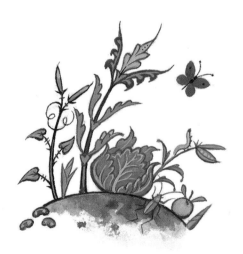

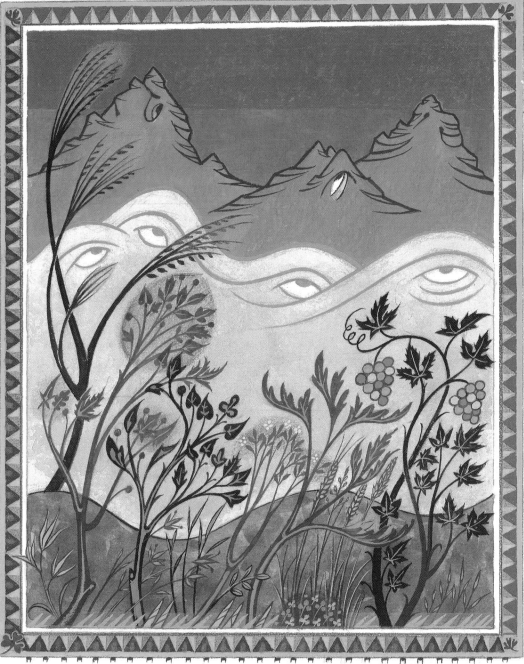

O ye Wells,

bless ye the Lord:

praise him, and magnify

him for ever.

O ye Seas and Floods,

bless ye the Lord:

praise him, and magnify

him for ever.

O ye Whales, and all that

move in the Waters,

bless ye the Lord,

praise him, and magnify

him for ever.

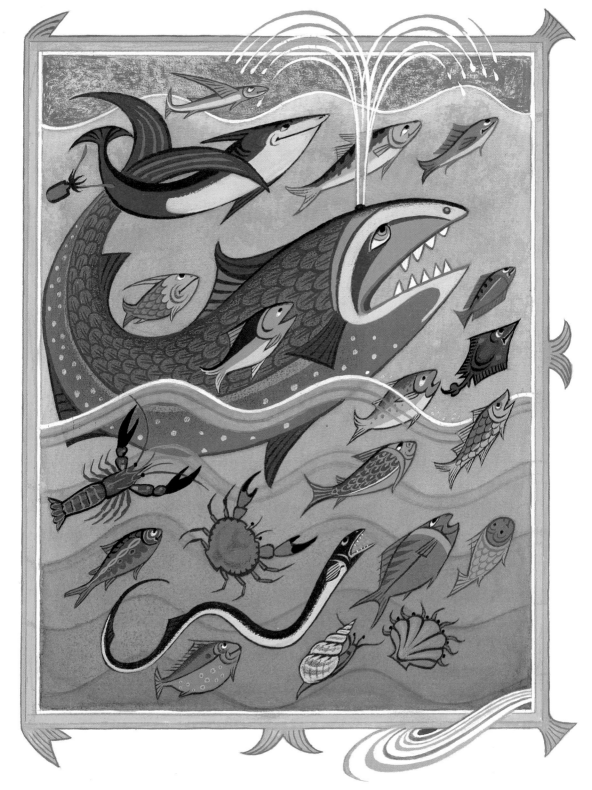

O all ye Fowls of the Air,
bless ye the Lord:
praise him, and magnify
him for ever.
O ye Beasts and Cattle,
bless ye the Lord:
praise him, and magnify
him for ever.

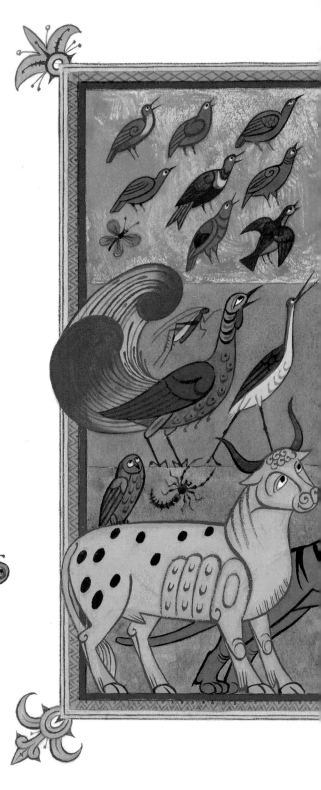

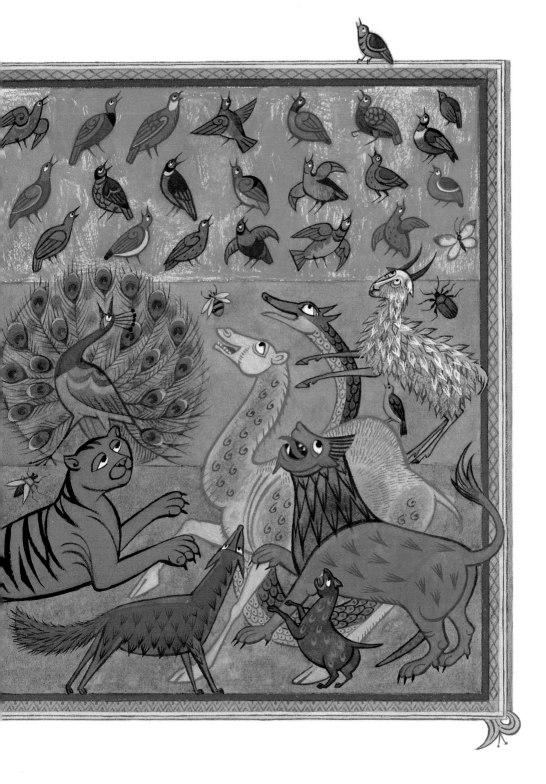

O ye Children of Men,
bless ye the Lord:
praise him, and magnify
him for ever.
O let Israel
bless the Lord:
praise him, and magnify
him for ever.

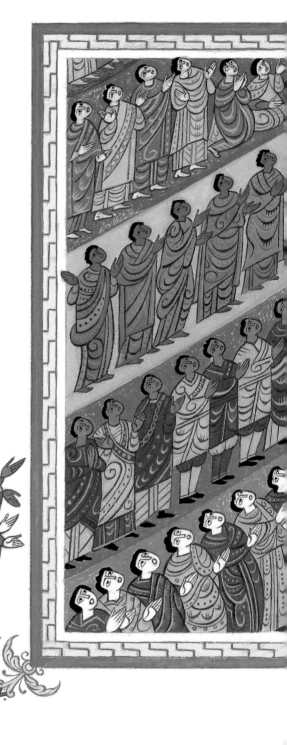

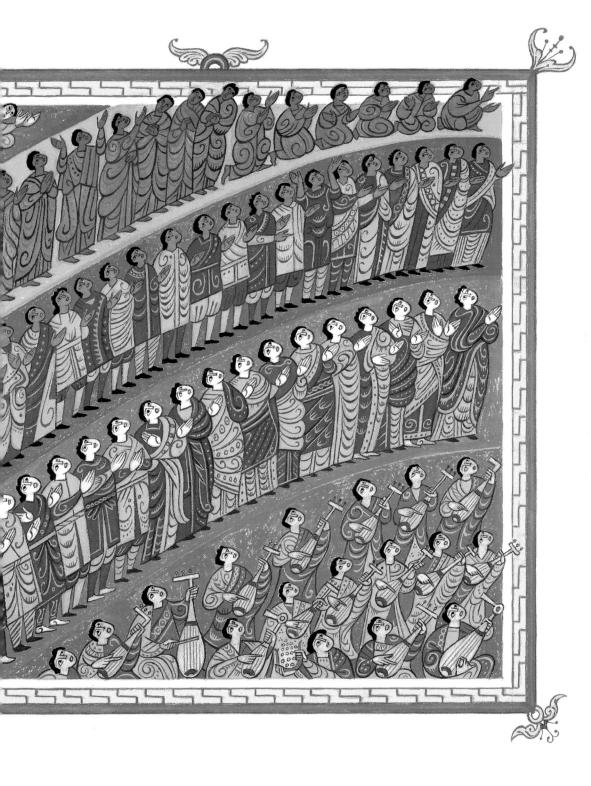

O ye Priests of the Lord,
bless ye the Lord:
praise him, and magnify
him for ever.
O ye Servants of the Lord,
bless ye the Lord:
praise him, and magnify
him for ever.

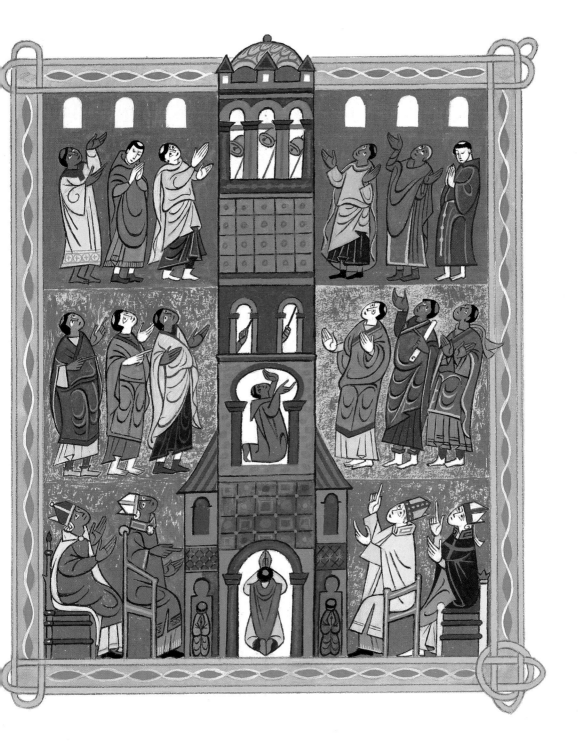

O ye Spirits and Souls
of the Righteous,
bless ye the Lord:
praise him, and magnify
him for ever.
O ye holy and humble
Men of Heart,
bless ye the Lord:
praise him, and magnify
him for ever.
O Ananias, Azarias, and Misael,
bless ye the Lord:
praise him, and magnify
him for ever.

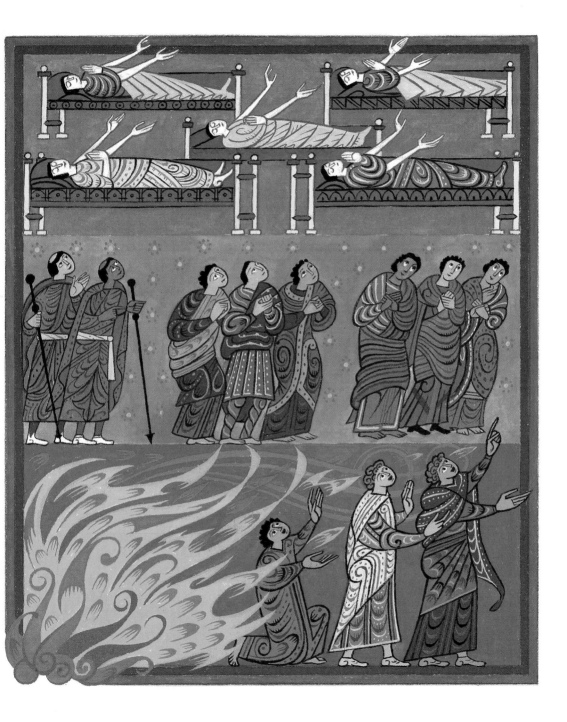

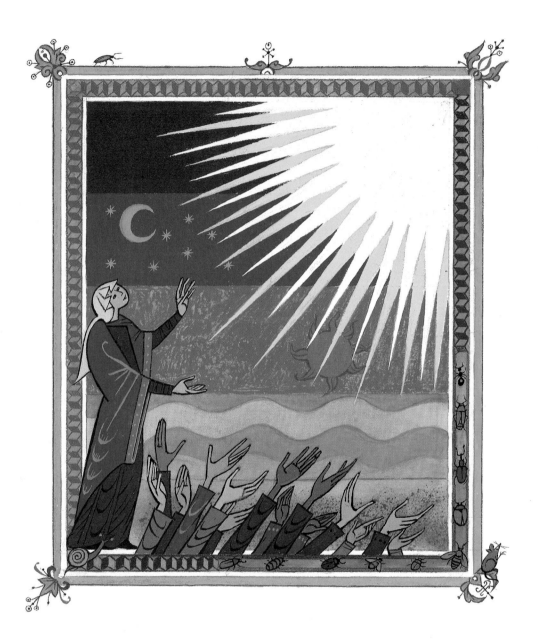